Adult Coloring Book
It's Raining Cats & Dogs (Vol. 1)

Fat Kat Publishing

Copyright © 2016 by Fat Kat Publishing

All rights reserved.

No part of this book may be reproduced in any form or by any electronic or mechanical means, including information storage and retrieval systems, without written permission from the publisher.

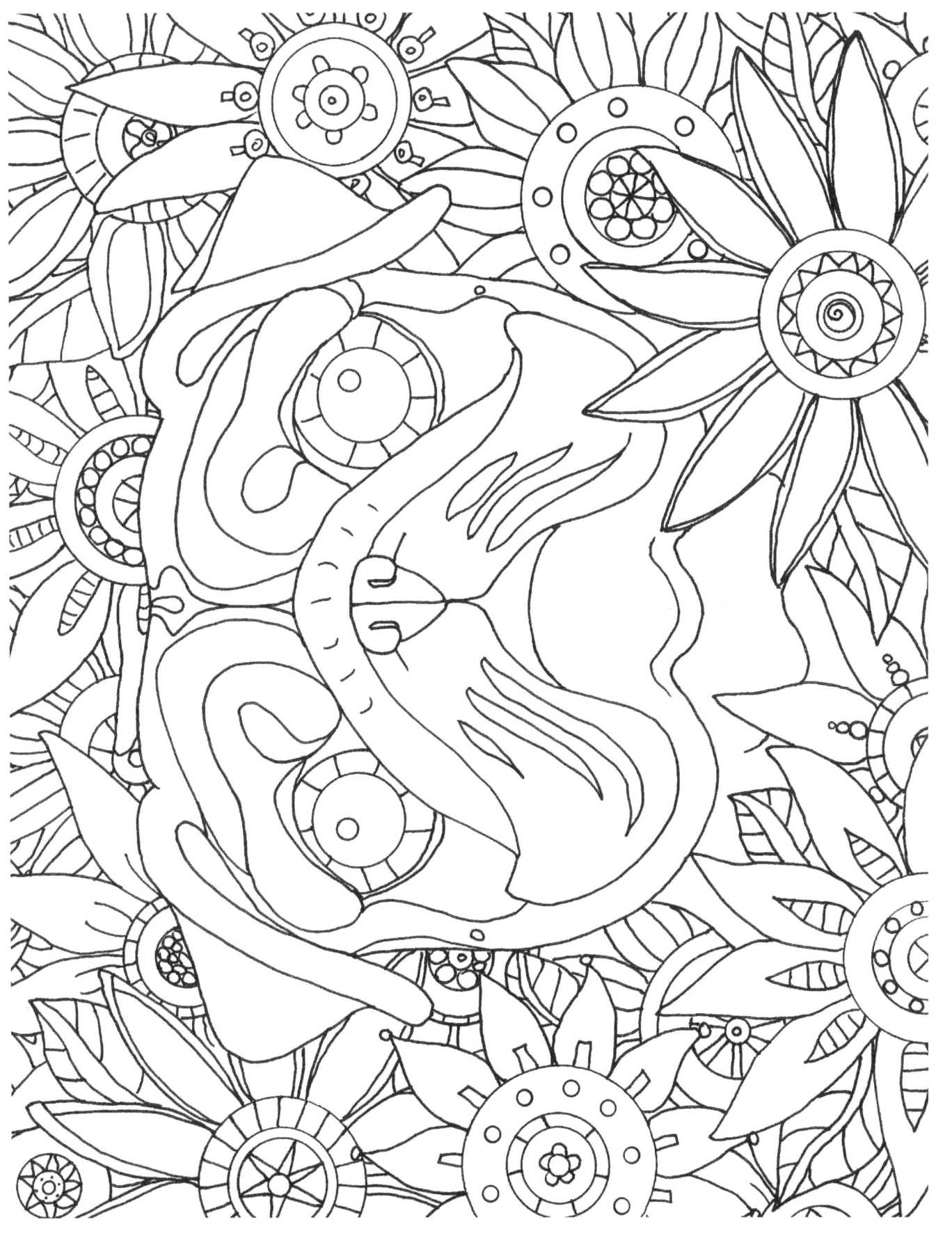

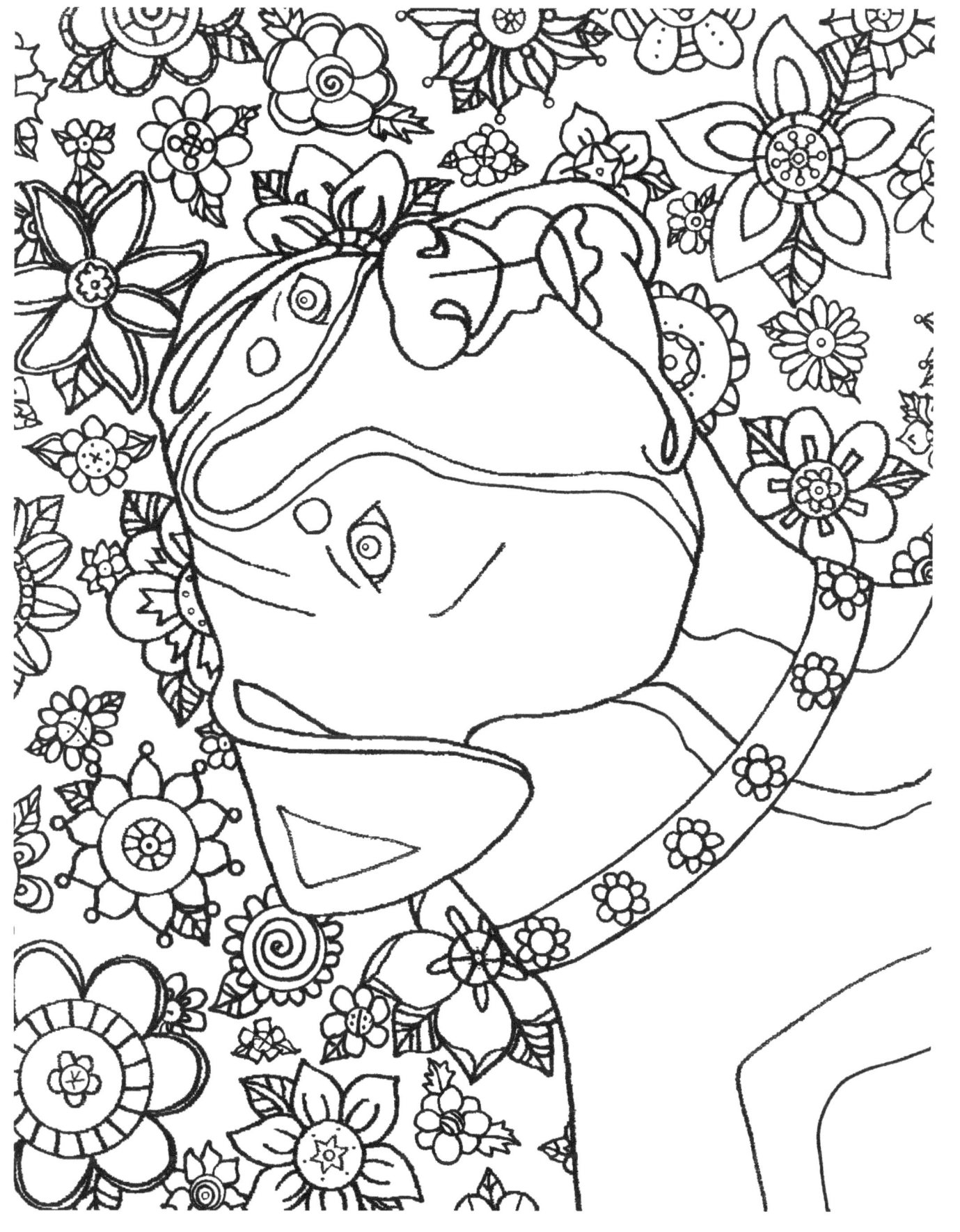

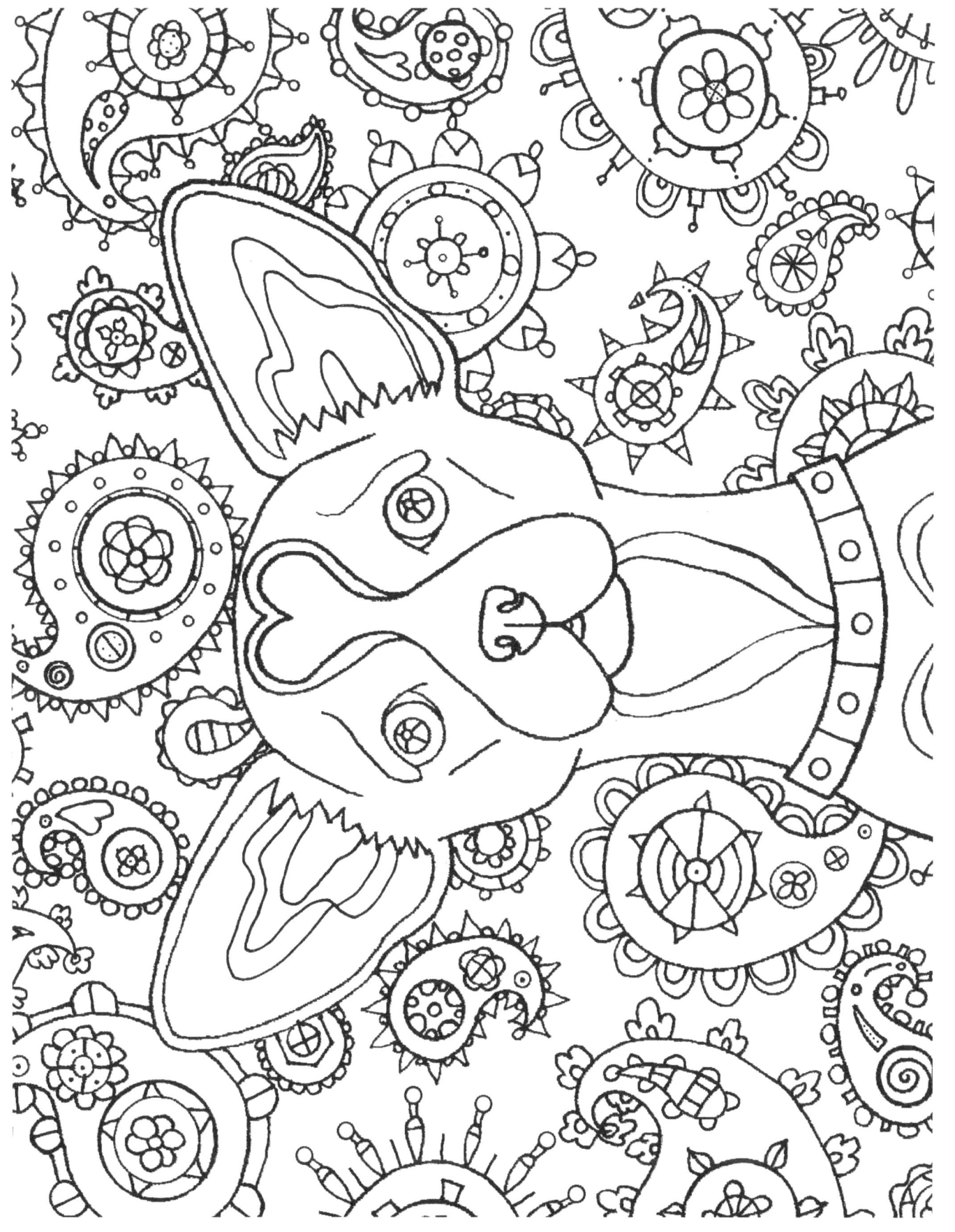

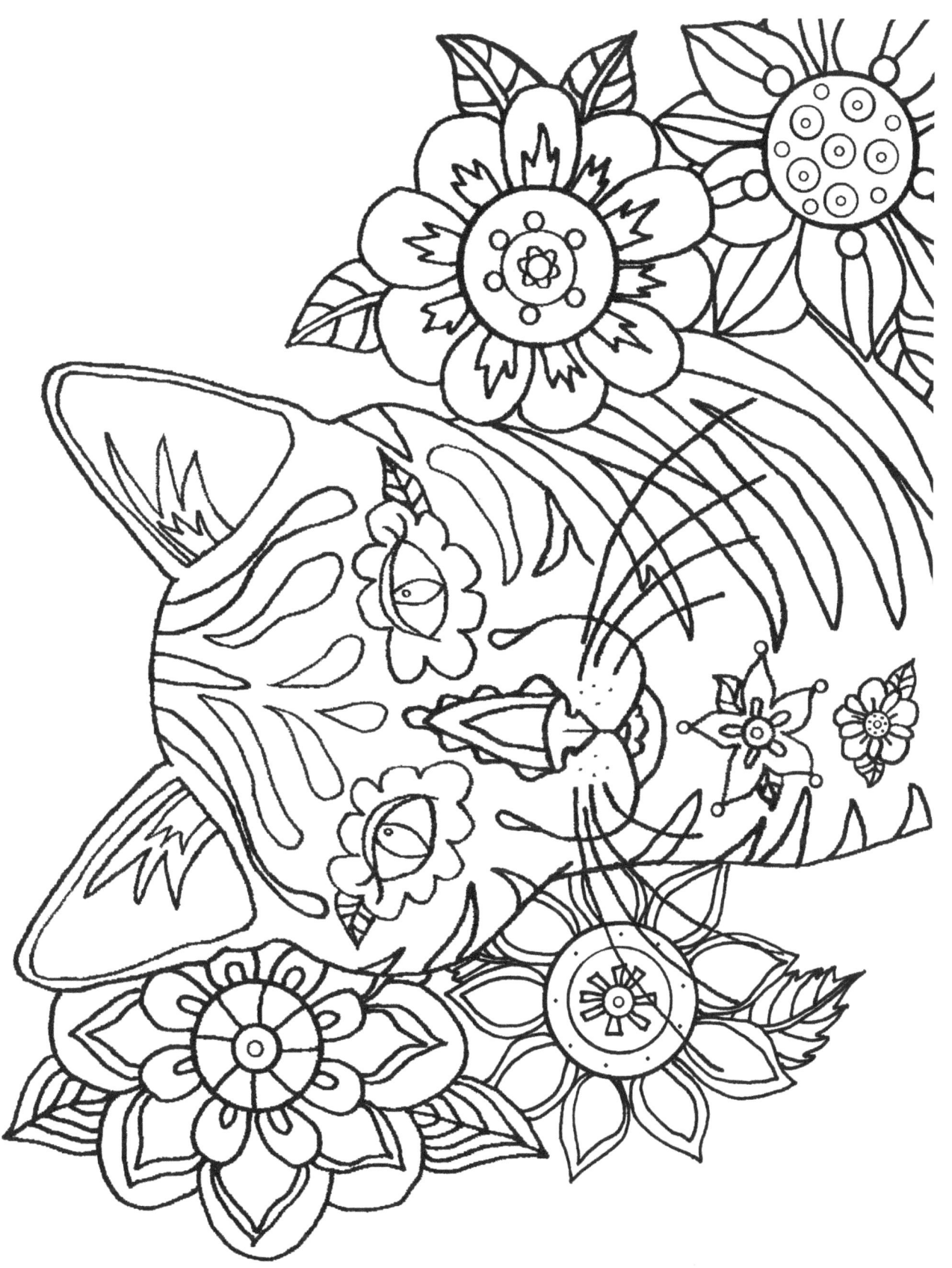

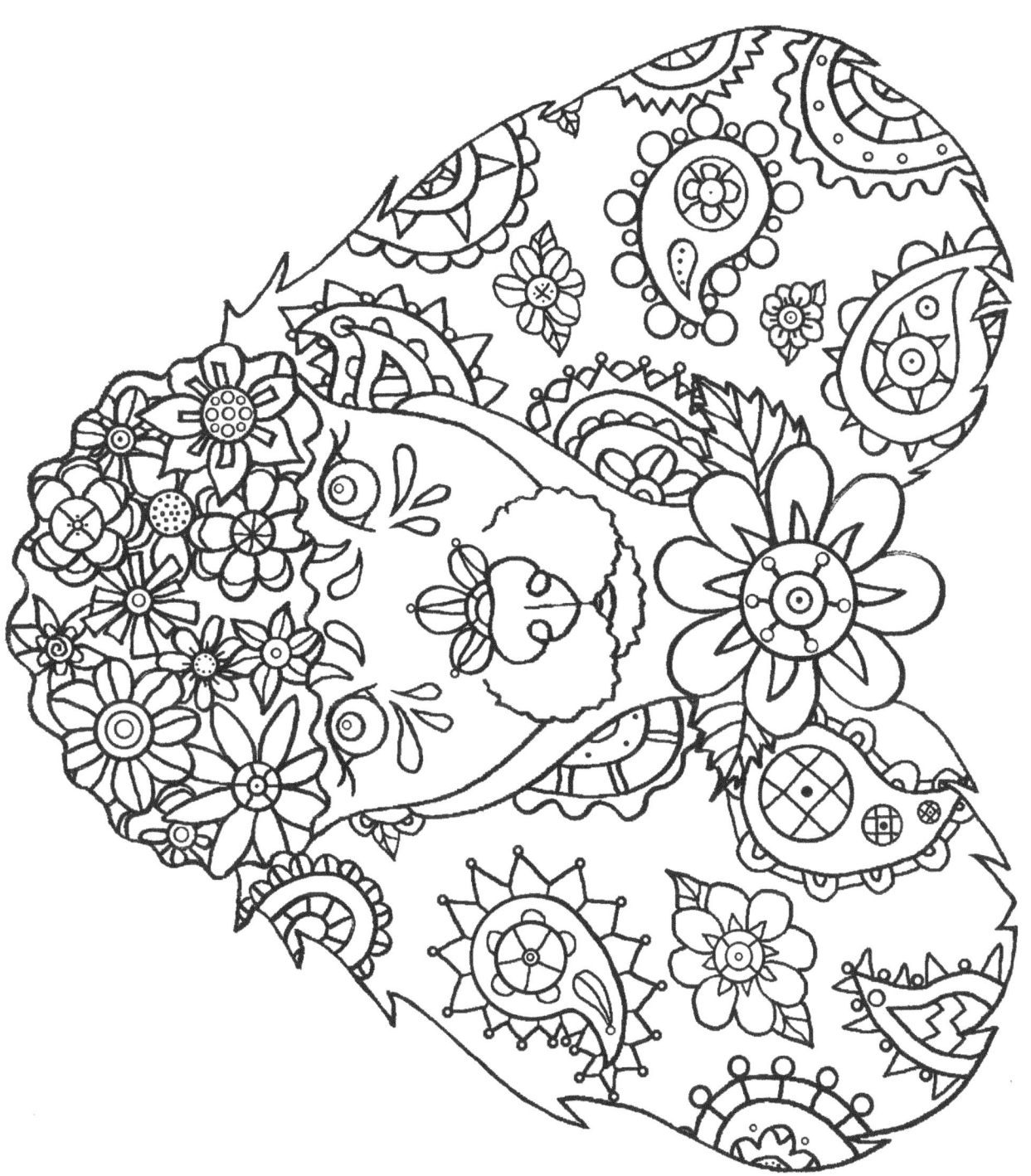

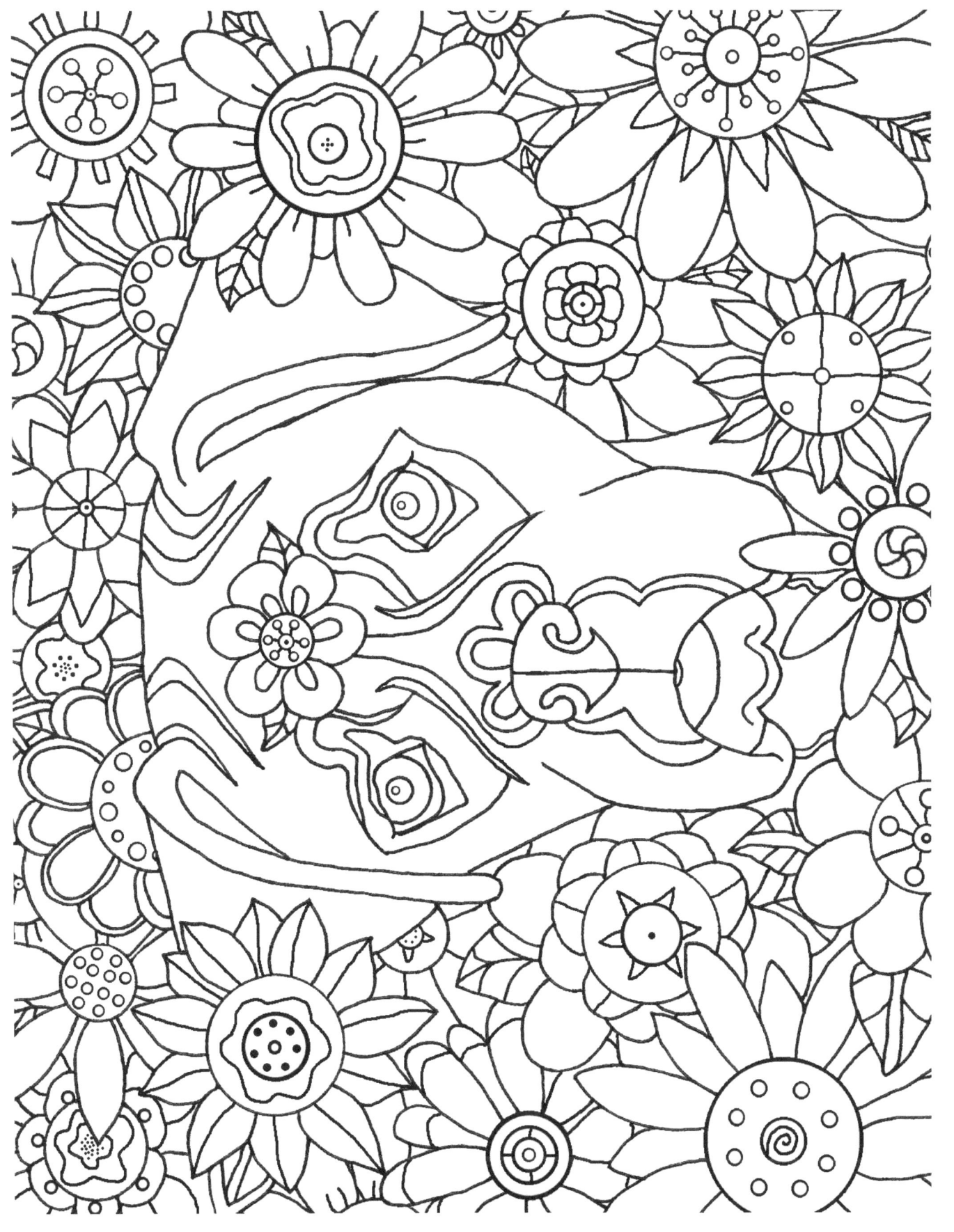

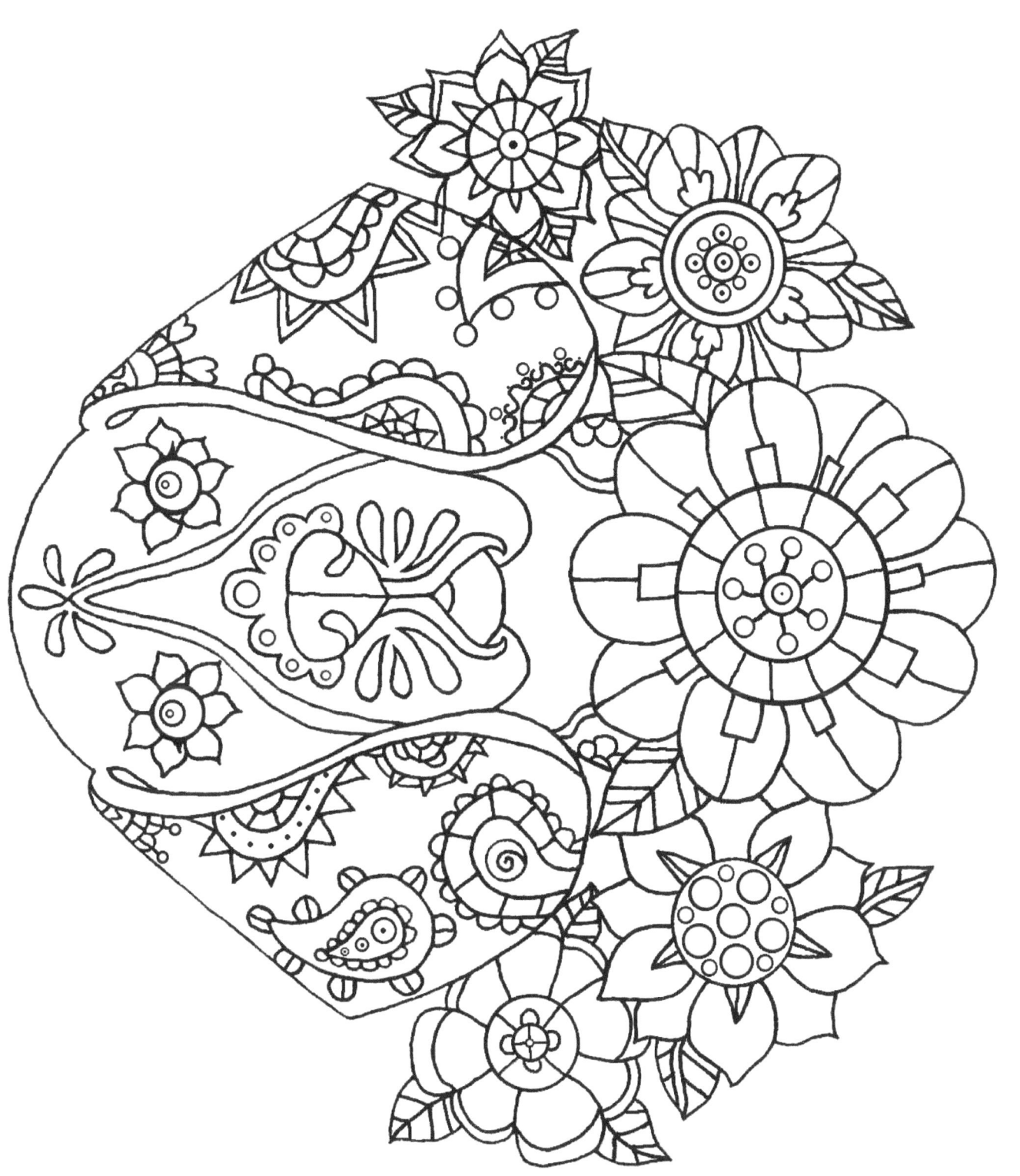

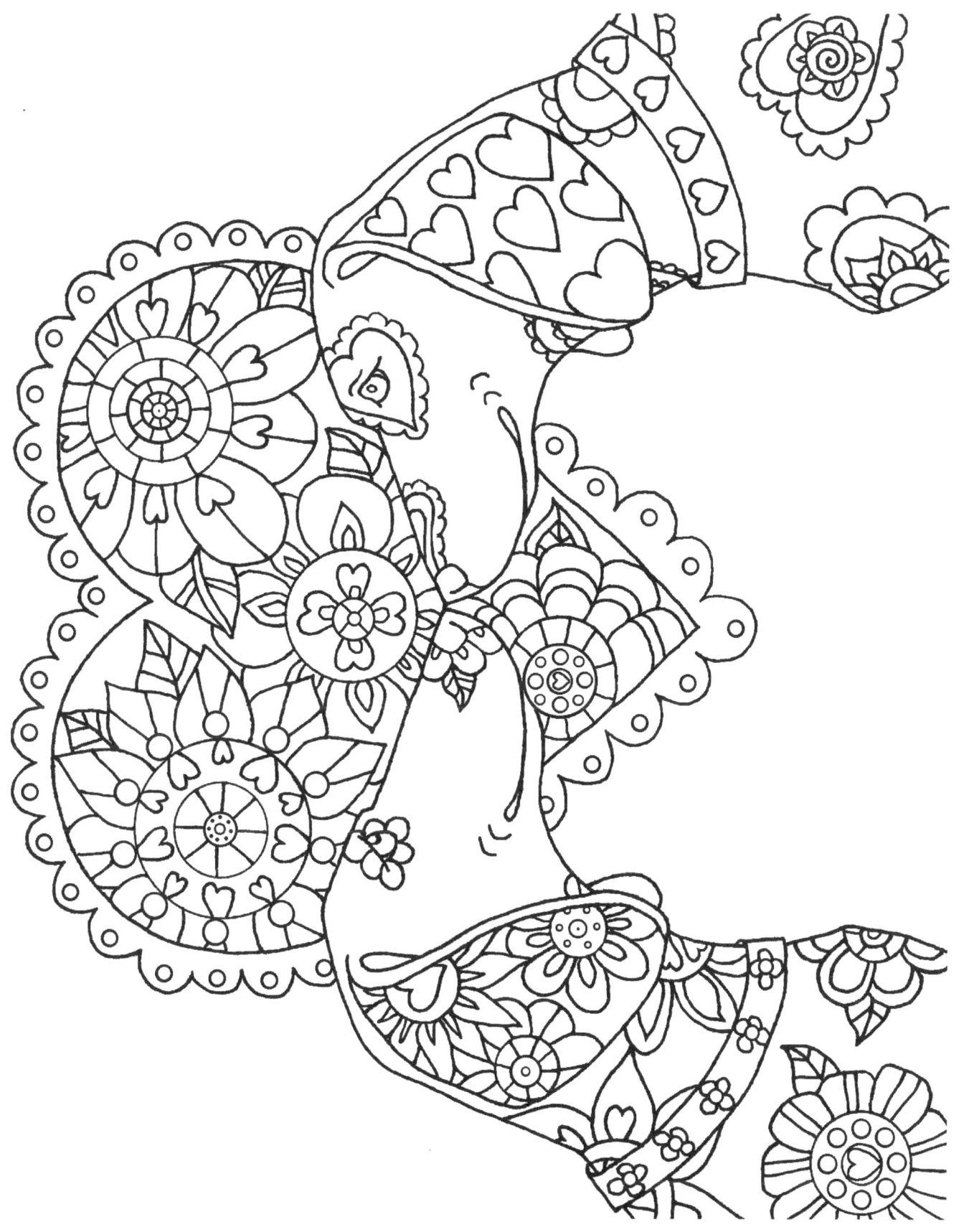

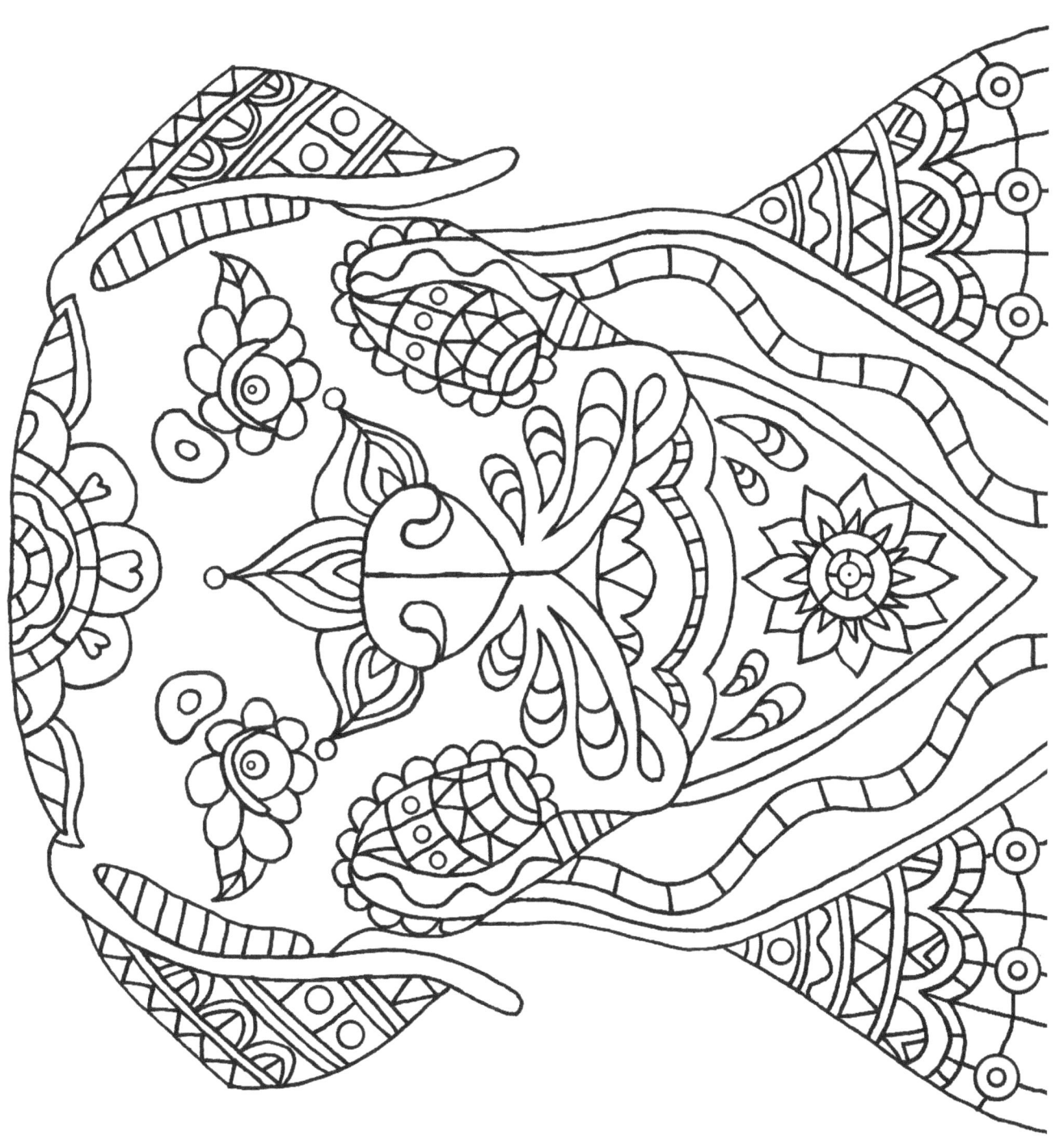

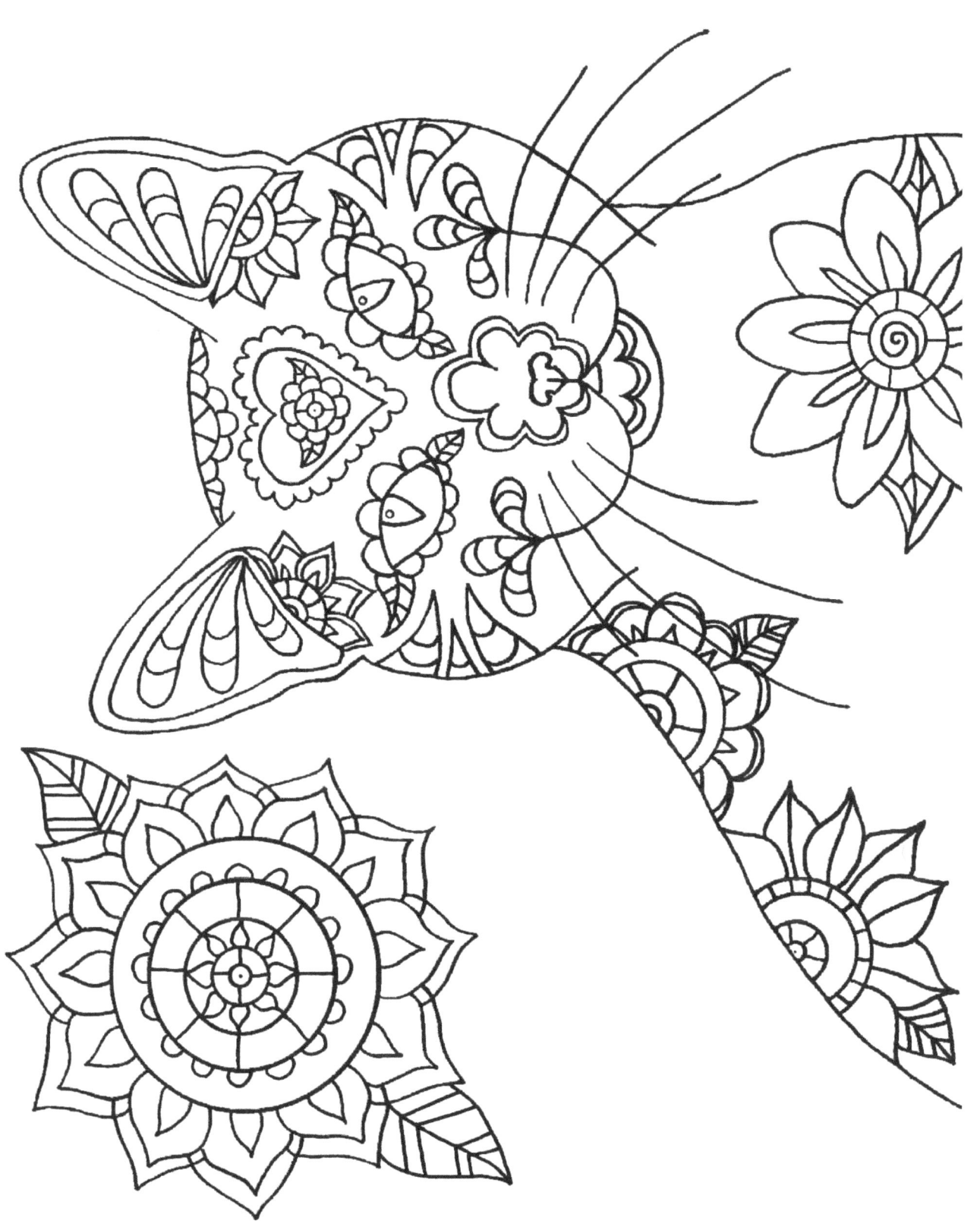

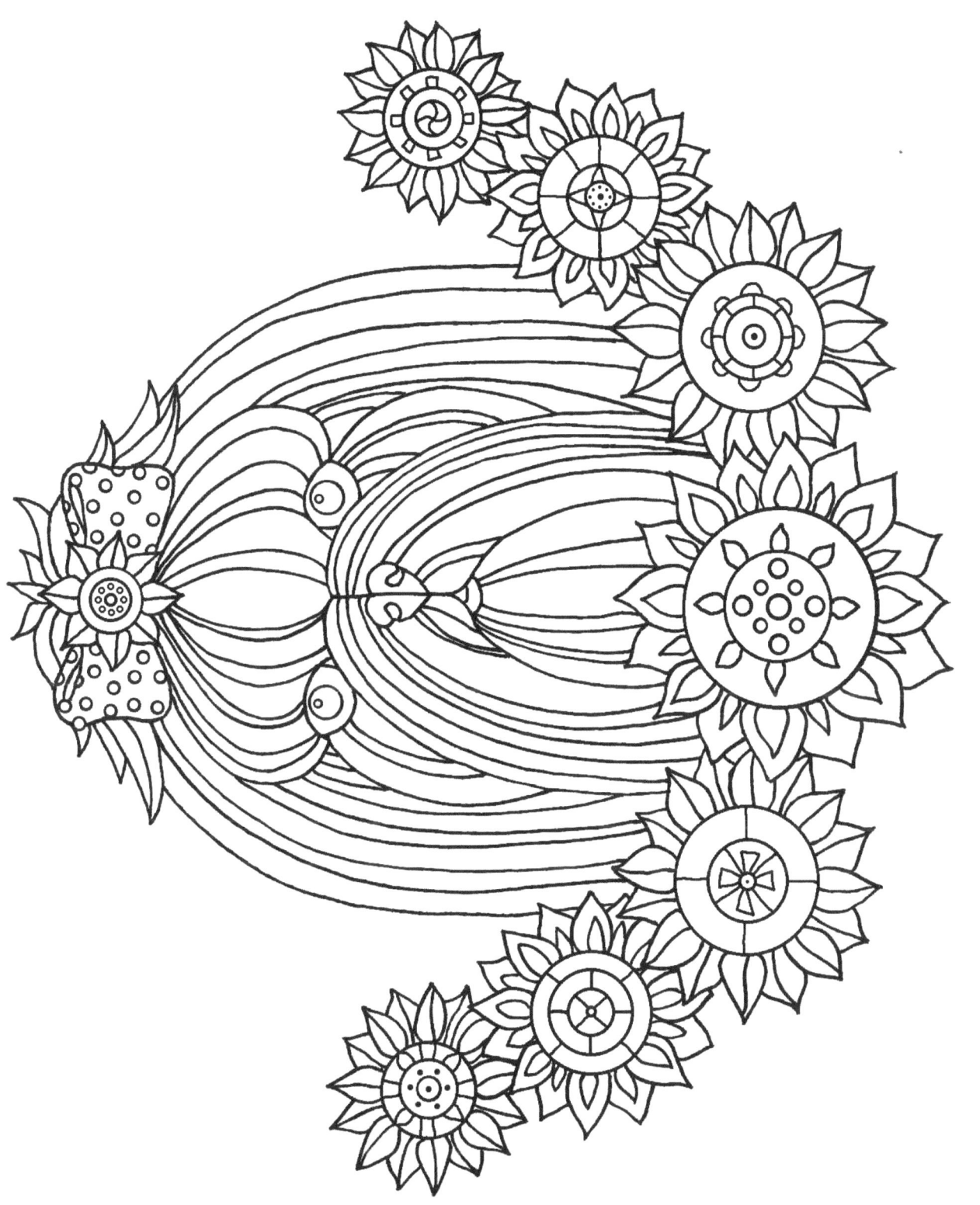

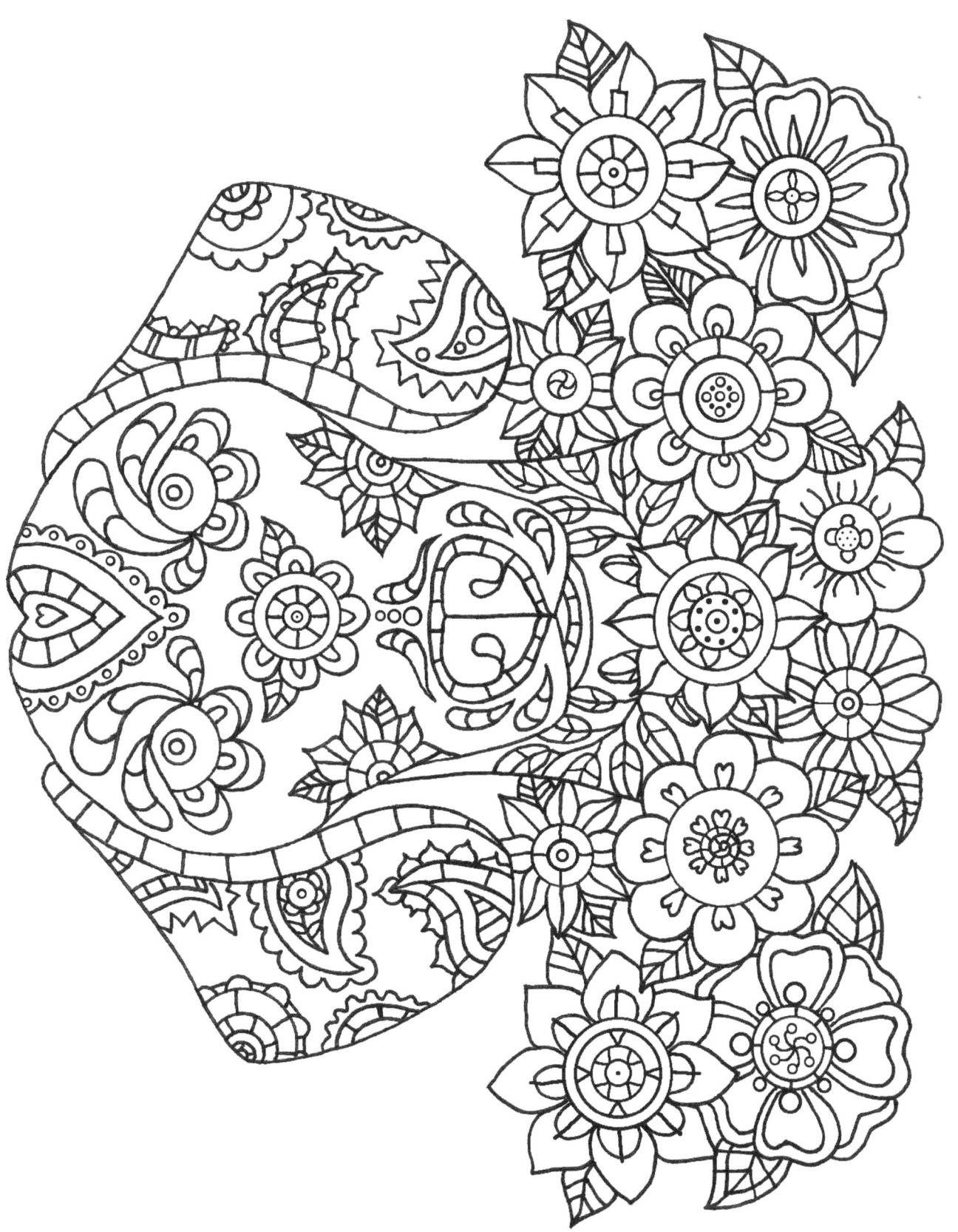

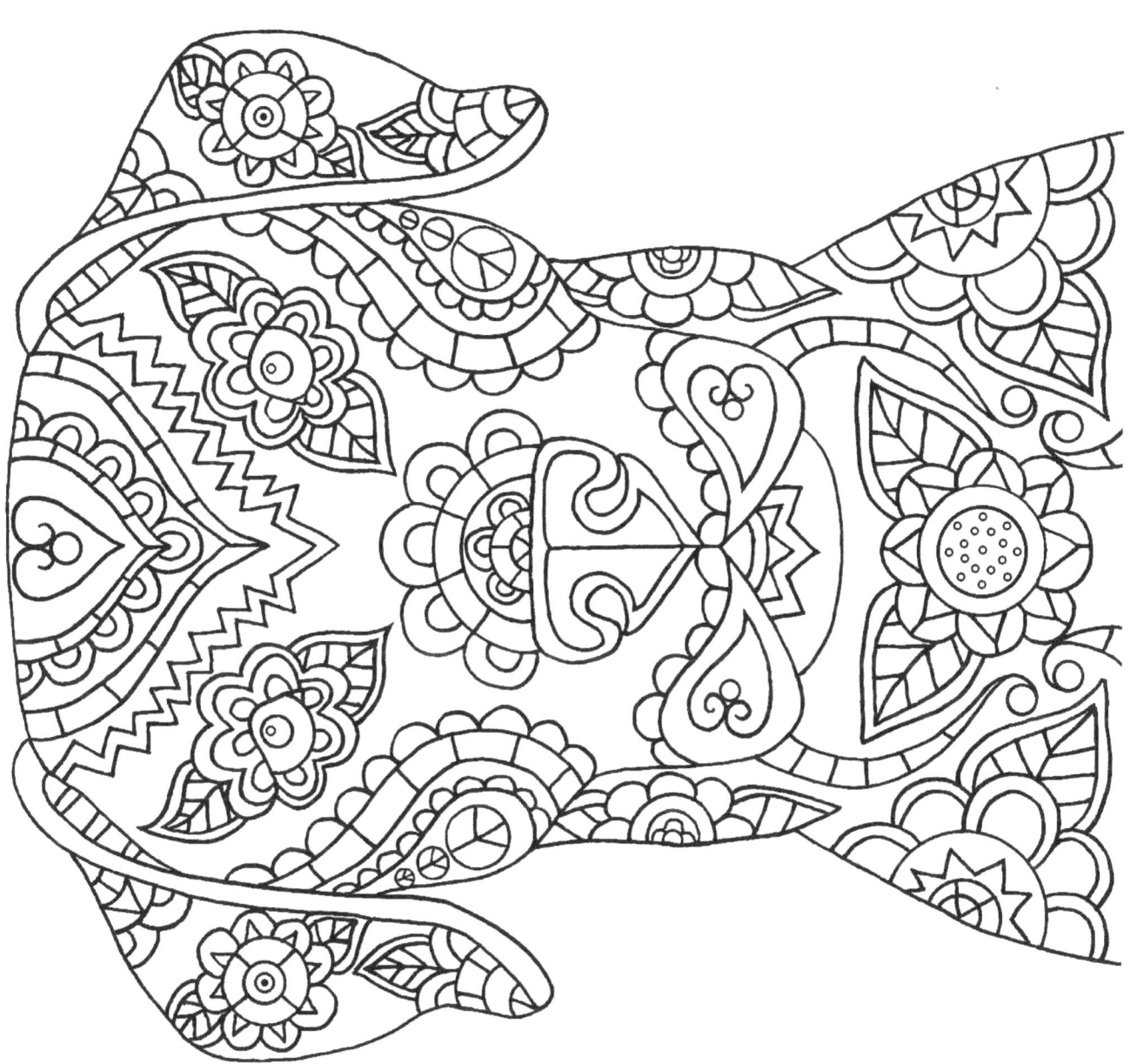

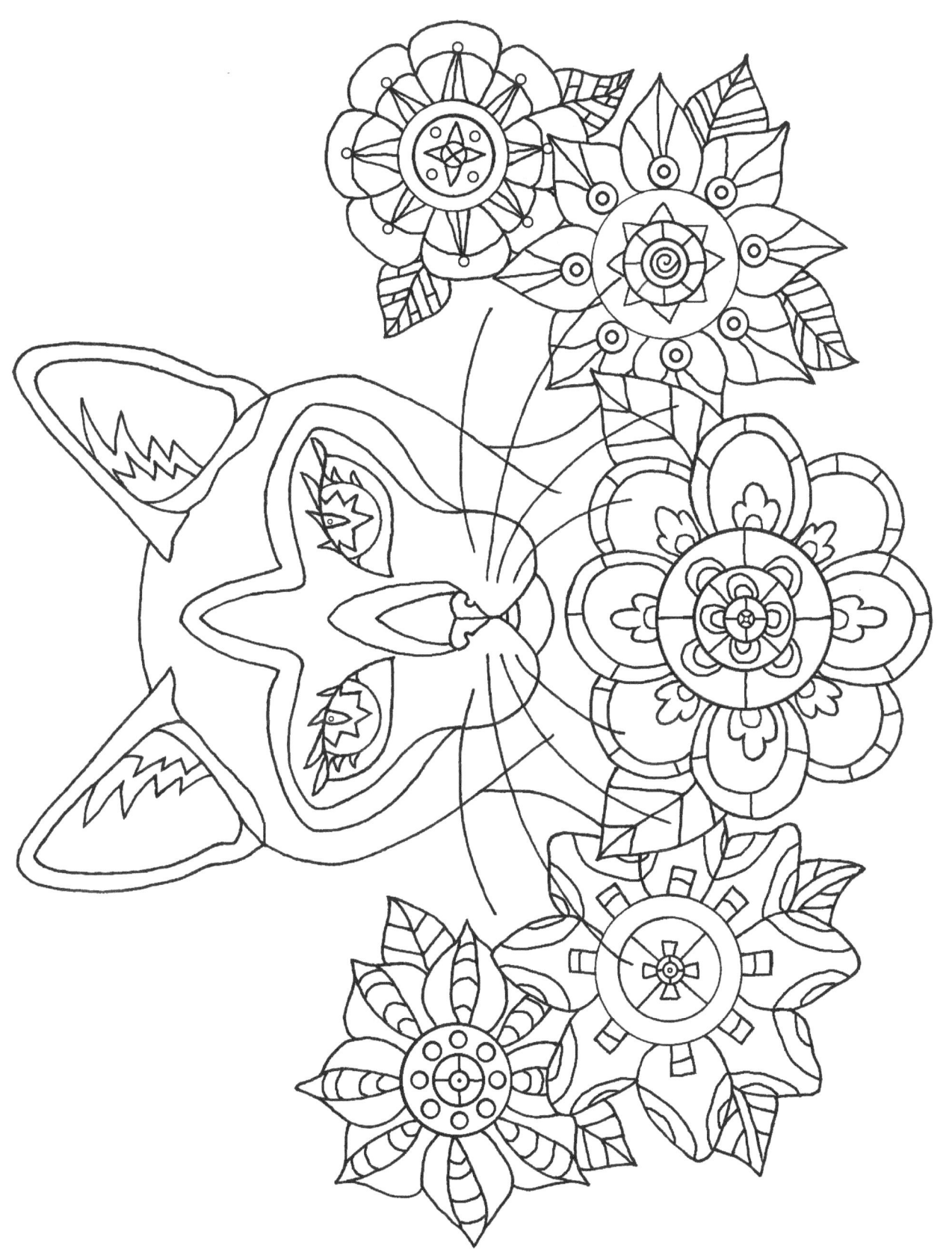

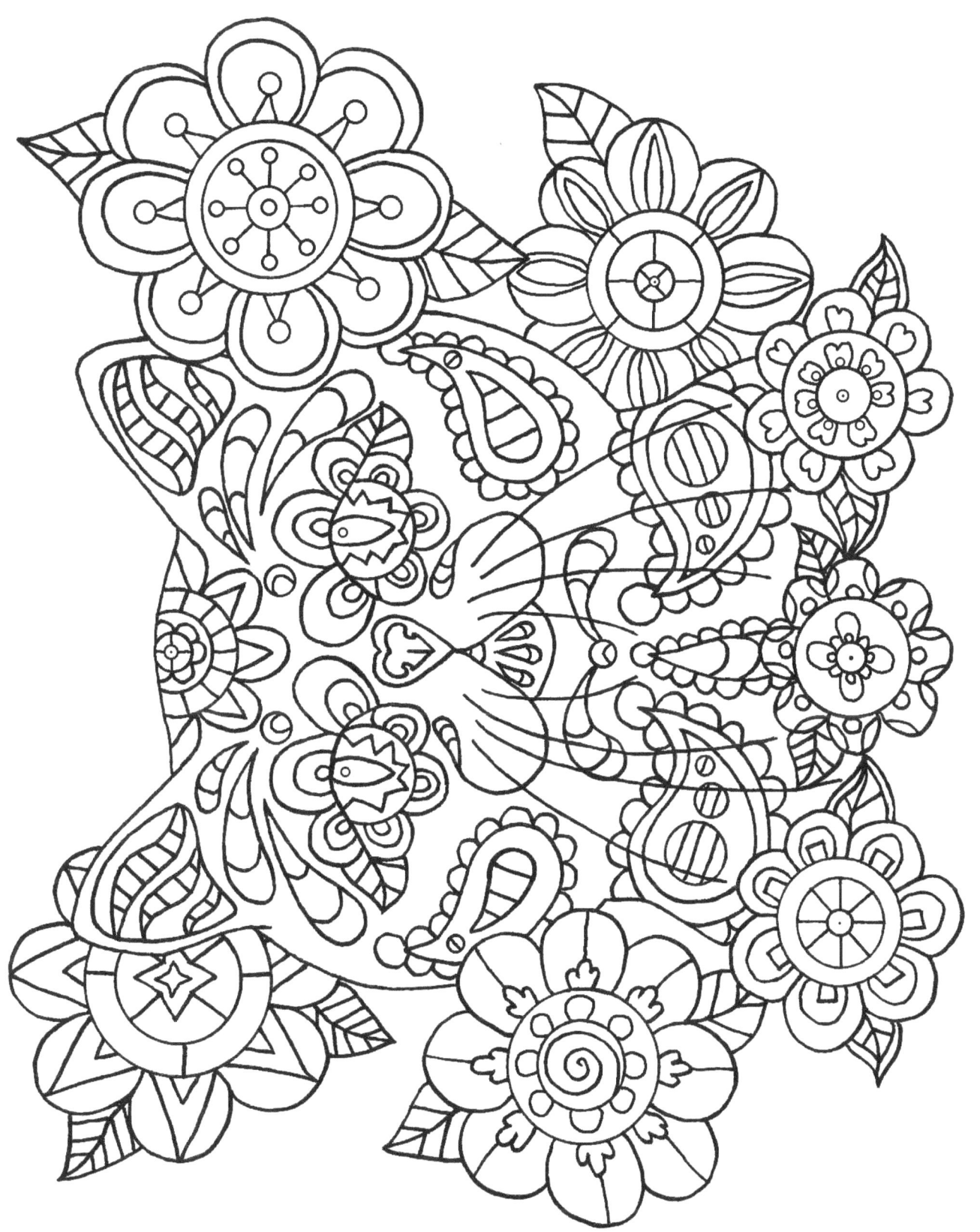

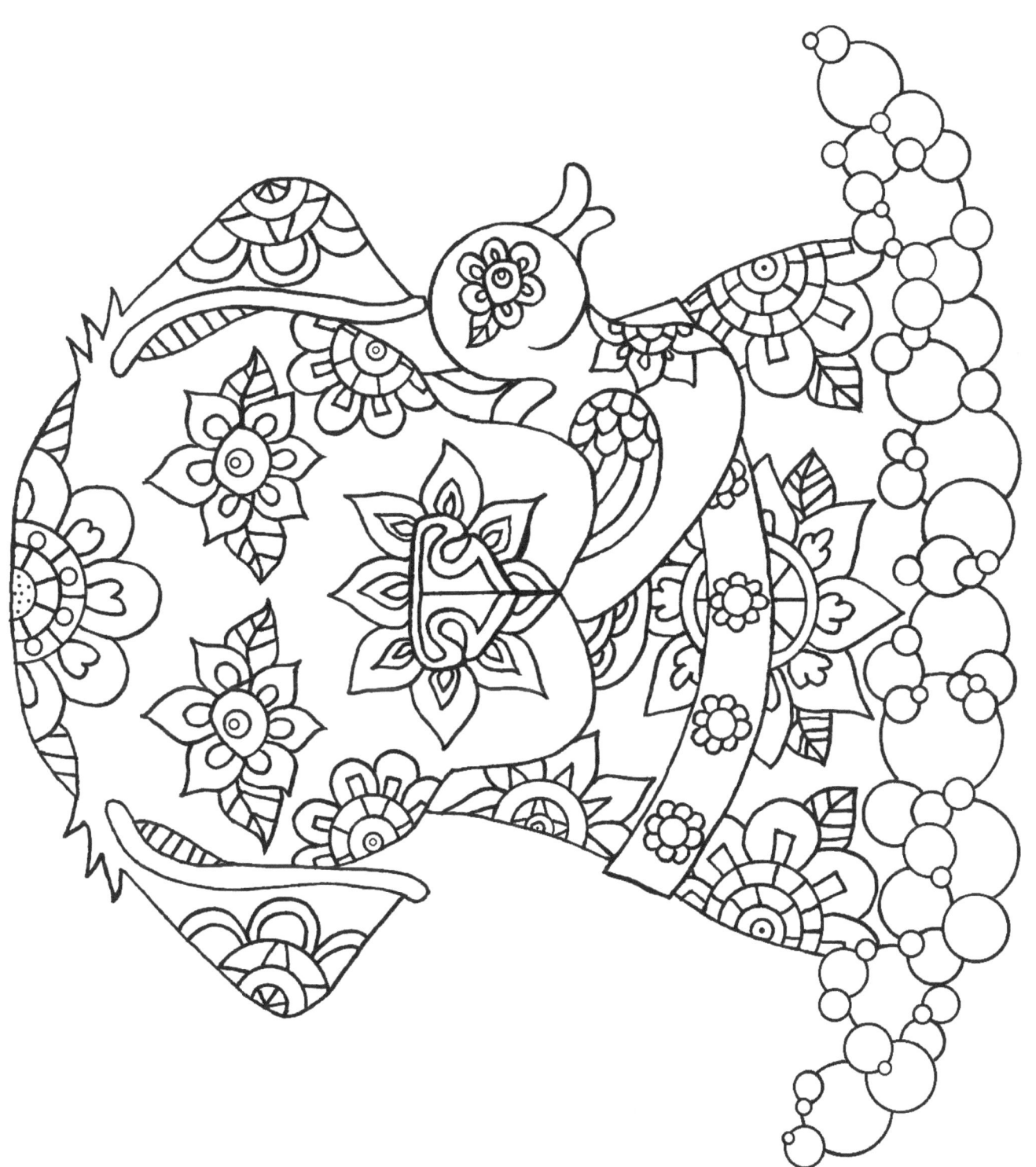

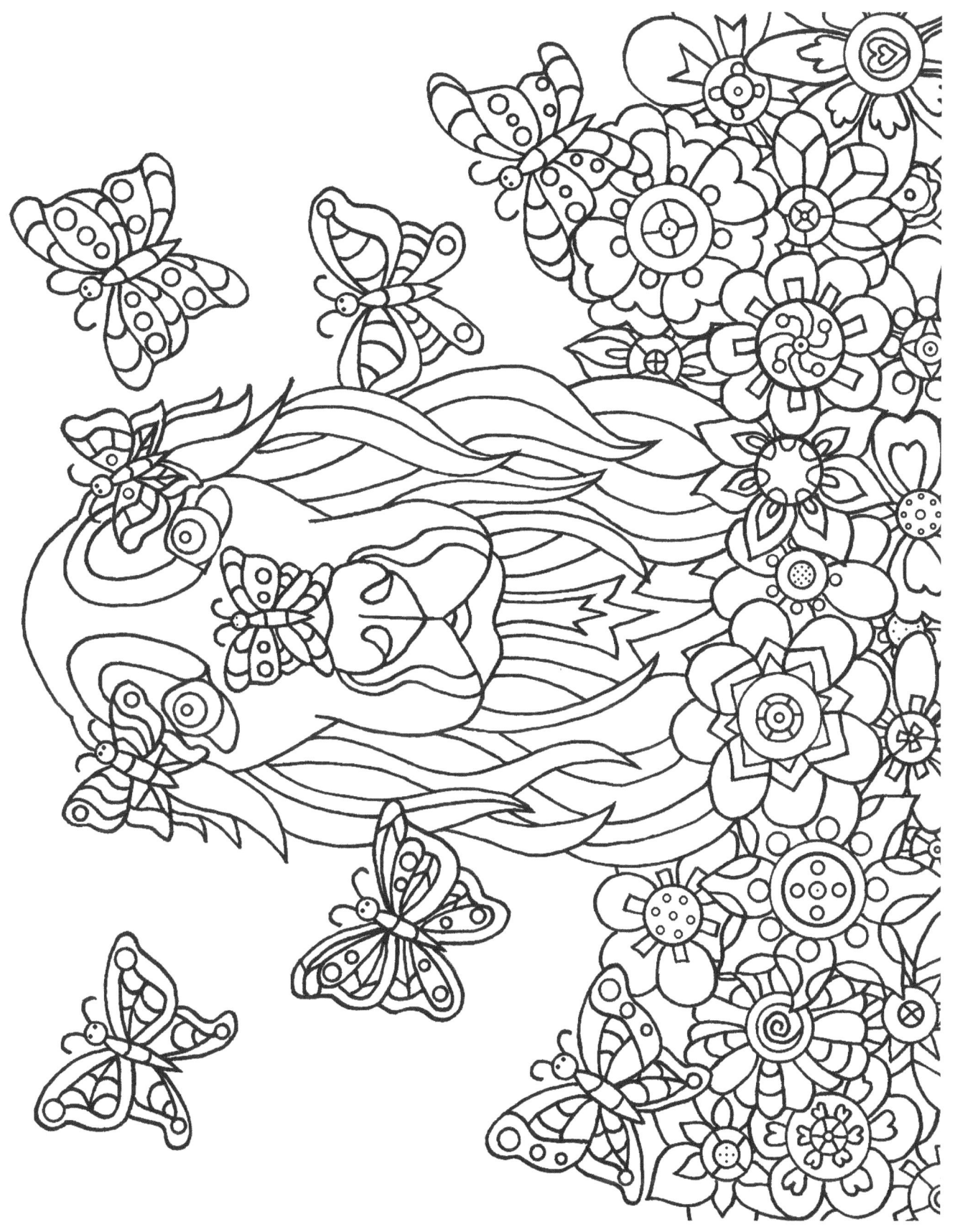

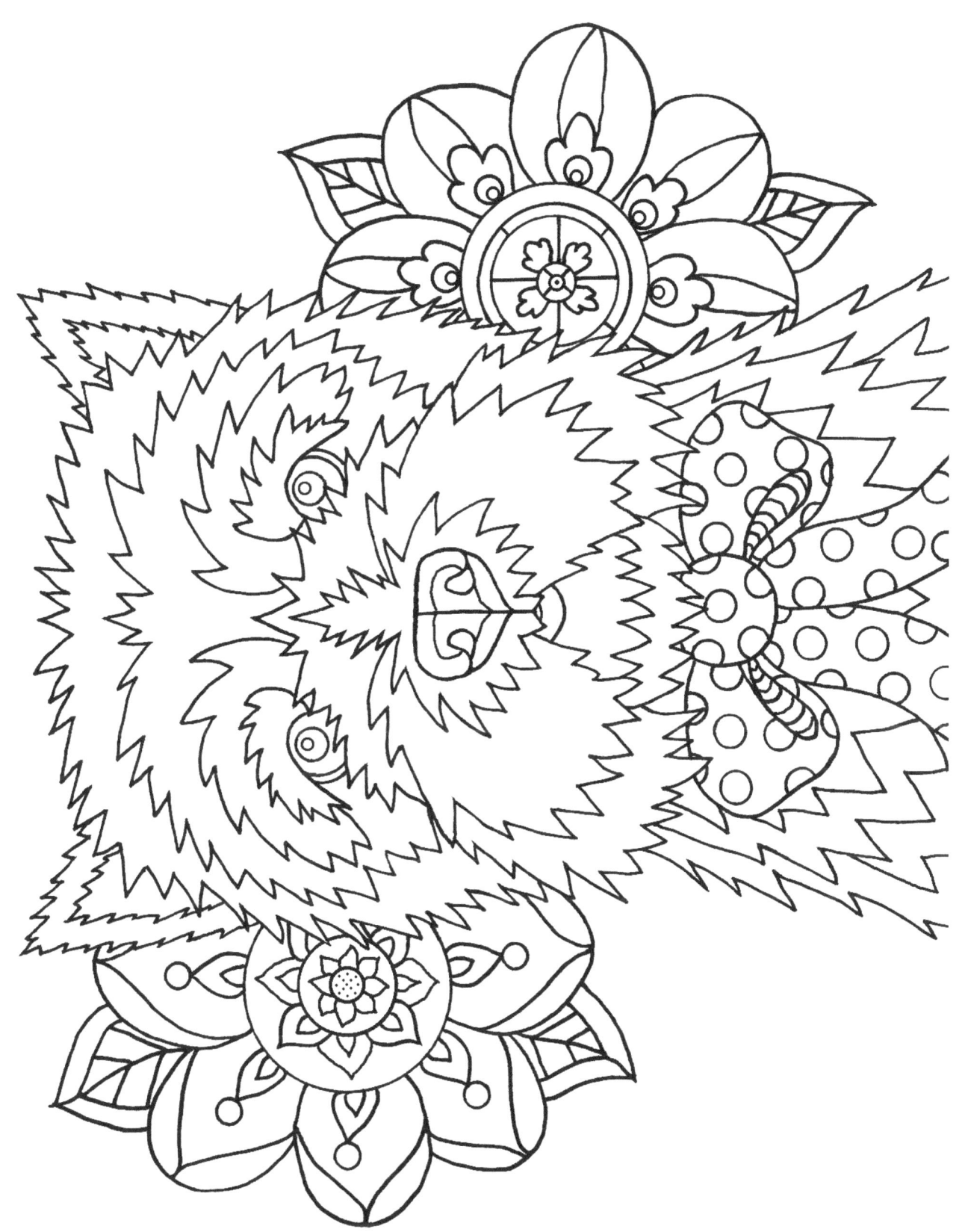

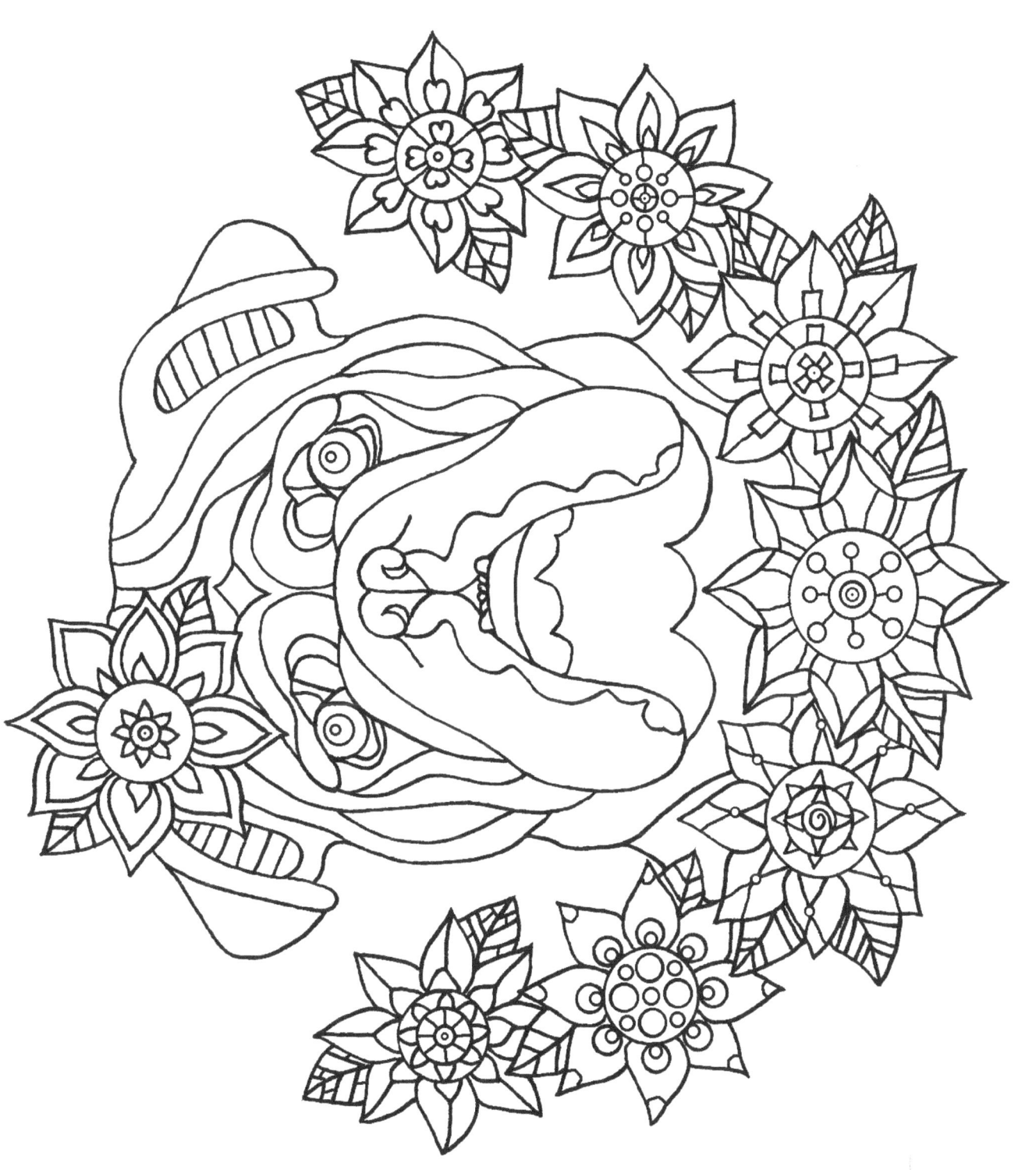

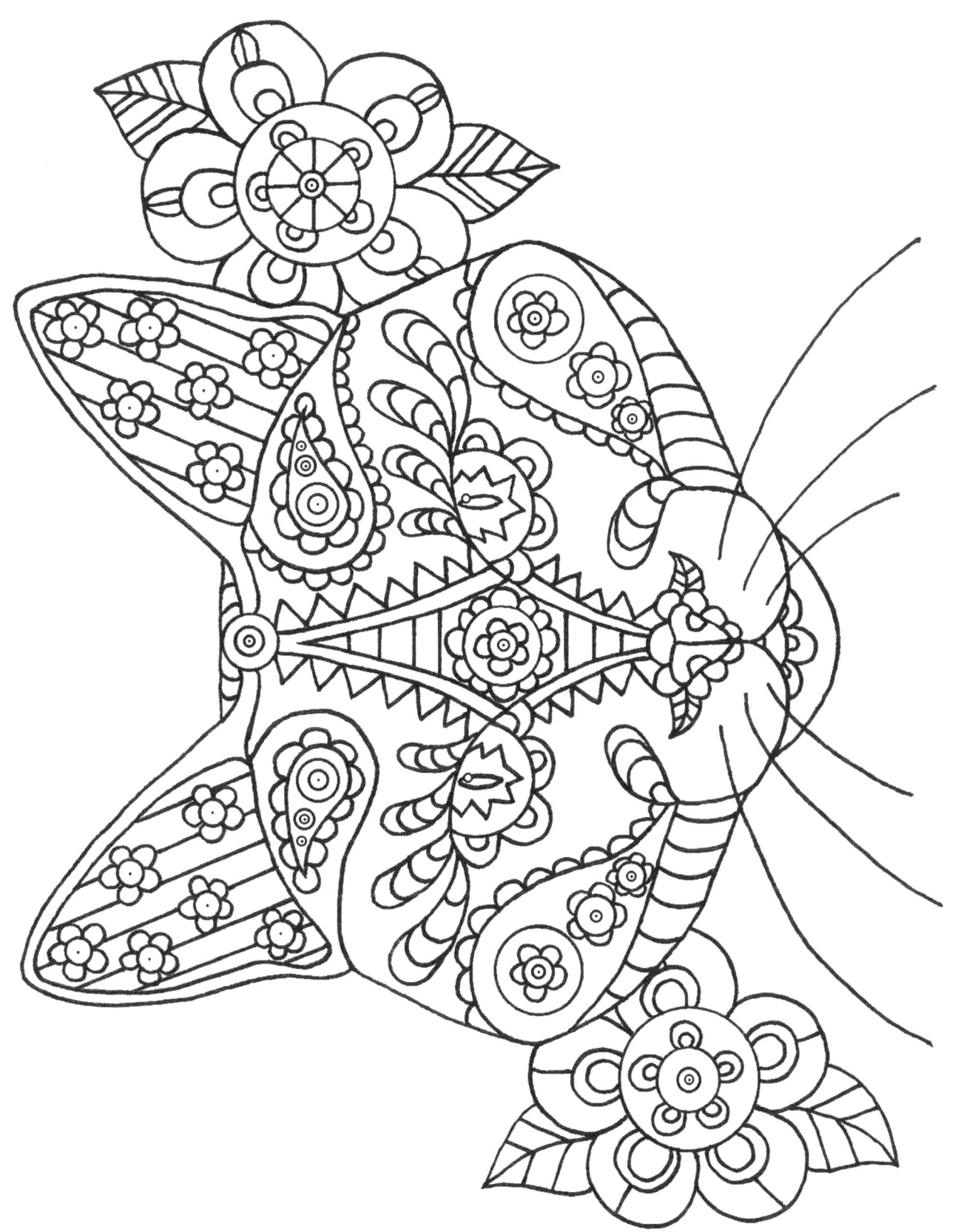

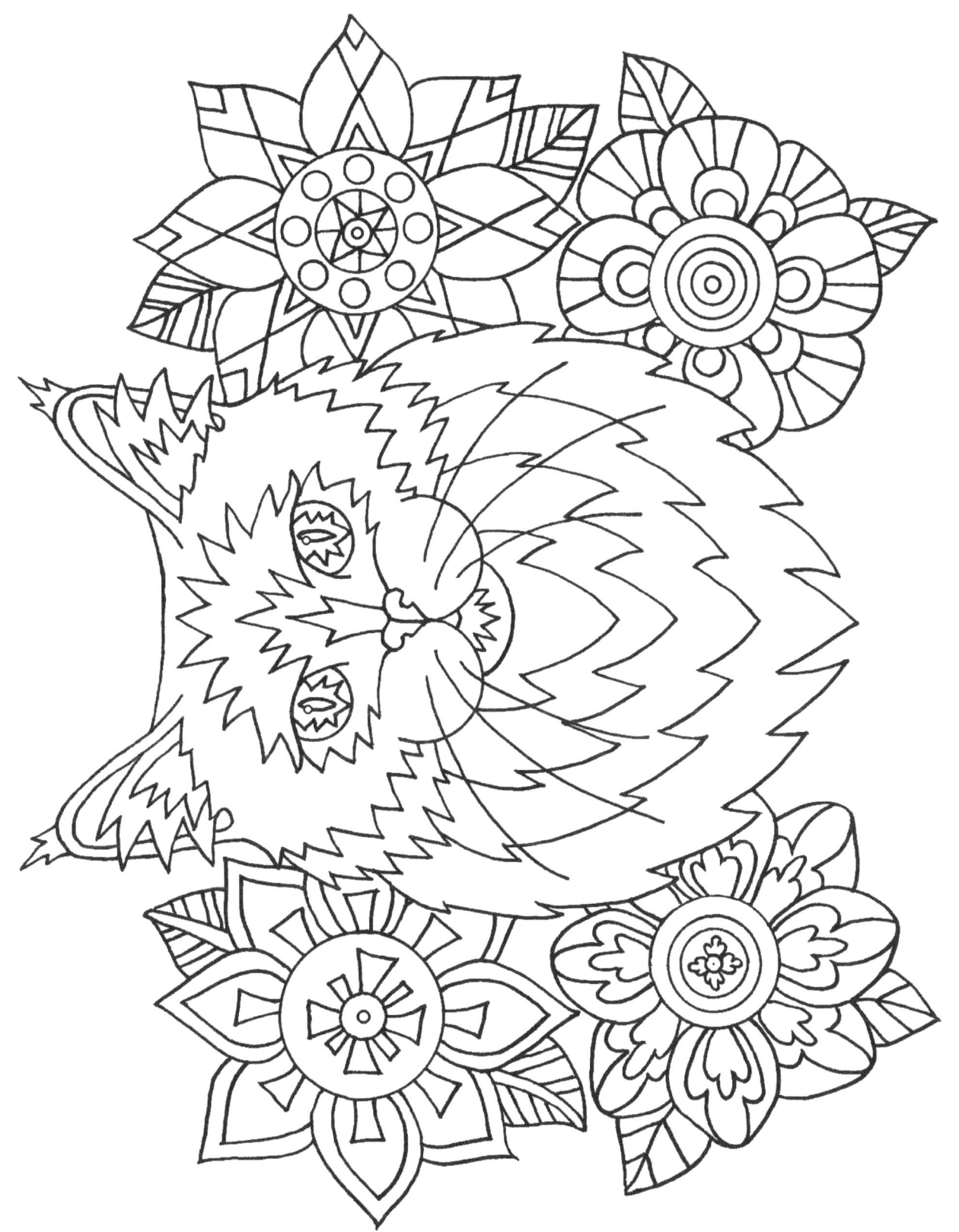

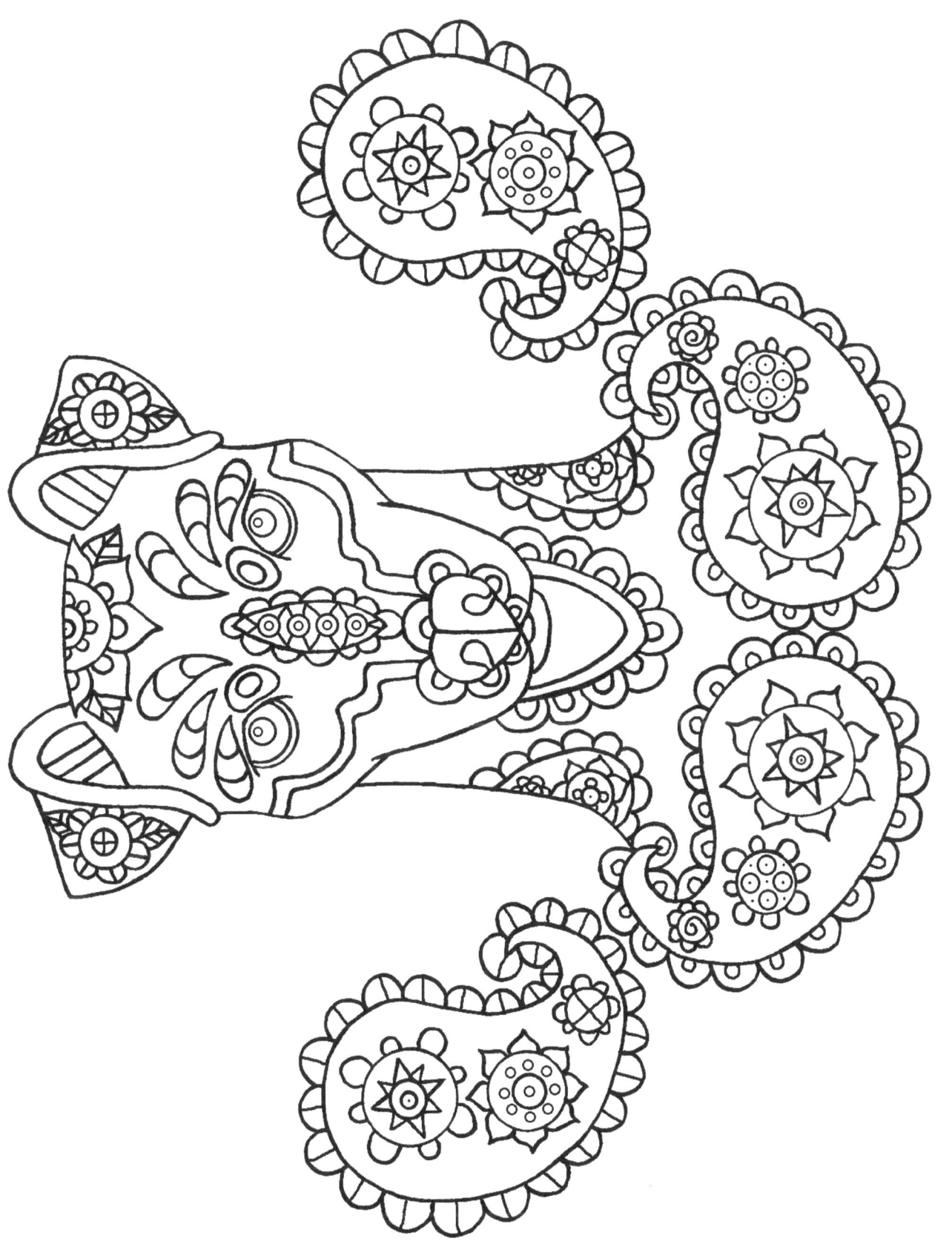

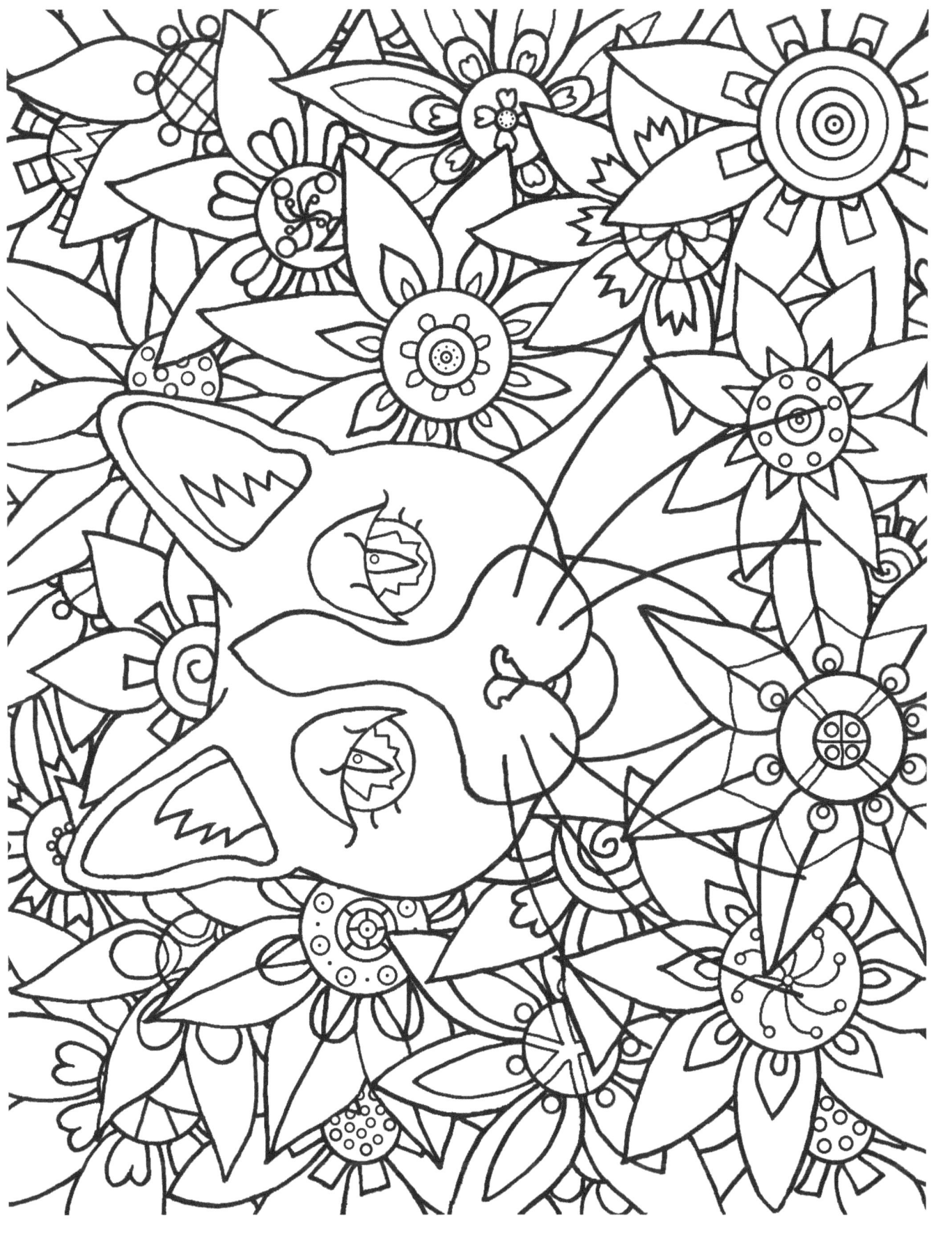

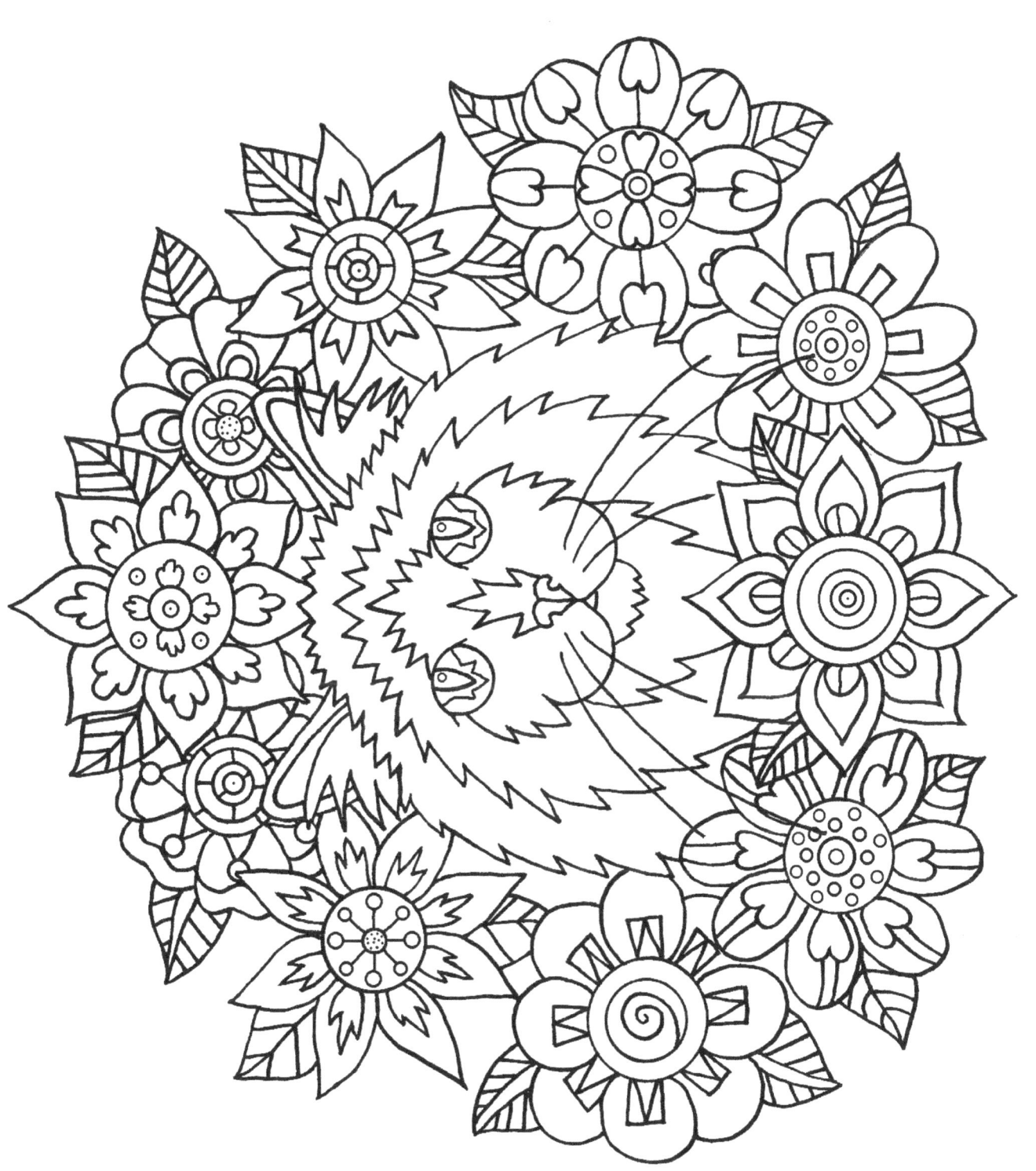

Acknowledgements

For Melinda. This wouldn't have been possible without your amazing artwork! Thank you so much for making this idea into a reality full of beauty.

And to all the fur-babies out there giving their owners unconditional love and affection.

www.ingramcontent.com/pod-product-compliance
Lightning Source LLC
Chambersburg PA
CBHW080546190526
45169CB00007B/2651